CHIC

SIMPLE

Components

"One should either
be a work of art, or wear a
work of art."

OSCAR WILDE

CHIC
SIMPLE
Components

SHIRT AND TIE

ALFRED A. KNOPF NEW YORK 1993

THIS IS A BORZOI BOOK
PUBLISHED BY ALFRED A. KNOPF, INC.

KIM JOHNSON GROSS JEFF STONE

WRITTEN BY MICHAEL SOLOMON
PHOTOGRAPHS BY JAMES WOJCIK
TIE ILLUSTRATIONS BY ANN FIELD
ICON ILLUSTRATION BY ERIC HANSEN
RESEARCHED BY KIMBERLY PASQUALE
STYLED BY JEFFREY MILLER

DESIGN AND ART DIRECTION BY ROBERT VALENTINE
INCORPORATED

Library of Congress Cataloging-in-Publication Data
Gross, Kim Johnson.
Chic Simple. Shirt and Tie/Kim Johnson Gross, Jeff Stone, and Michael
Solomon.
p. cm. – (Chic Simple)
ISBN 0-679-42766-X
1. Neckties. 2. Shirts, Men's. I. Stone, Jeff.
II. Solomon, Michael. III. Title. IV. Title: Chic Simple: Shirt and Tie. V. Title:
Shirt and Tie. VI. Series.
GT2120.G76 1993
391–dc20
93-20311
CIP

Manufactured in Mexico
First Edition

CONTENTS

"The more you know, the less you need."

C H I C
SIMPLE

Chic Simple is a primer for living well but sensibly in the 1990s. It's for those who believe that quality of life does not come in accumulating things, but in paring down to the essentials, with a commitment to home, community, and the environment. In a world of limited resources, Chic Simple enables readers to bring value and style into their lives with economy and simplicity.

THE SHIRT

For such a simple thing, a shirt has incredible power. It can make a portly man look slim or give a slender man some bulk. It is often a symbol of class, although the days of white collar versus blue are long gone. Above all, a shirt is something to be cherished because—as betting men know—it's the last thing you want to lose.

"You're the top!
You're an Arrow collar."

COLE PORTER

COLLAR

Ideally it should have a slight roll, no matter what collar style. Also, make sure the points are of identical length.

PLACKET

The fabric strip on which the buttons are sewn gives the shirt a clean center line.

SINGLE-NEEDLE STITCHING

A single needle is used to sew one side of the garment at a time. It produces more durable seams and fits better against the body.

SPLIT SHOULDER YOKE

Derived from custom-made techniques, it allows for more movement in the shoulder.

BUTTONS

Cross-stitched mother-of-pearl buttons are the highest quality—but they break more easily than plastic.

GAUNTLET BUTTONS

Keeps the sleeve opening closed so that sexy forearm doesn't show.

LONG TAILS

They should be long enough to cover the seat.

Fit. The most important consideration when buying a shirt is comfort. You don't want it to be so large that you look like you're wearing a spinnaker, but there's no reason to look as though you sprayed it on. It should be full enough so you can move comfortably without it pulling, but not so full that it ruins the line of the jacket. The cuff should show approximately one-half inch beneath the sleeve of the jacket. A shirt that fits properly should have a neckband with enough room—according to researchers at Cornell, a tight-fitting shirt and tie can cause vision impairment—so that you can get two or three fingers in when buttoned. Look carefully at the collar of a shirt before buying it. A fine dress shirt will have stitching on the collar—about a quarter of an inch from the edge—which keeps the material from buckling.

"It is quality rather than quantity that matters."

LUCIUS ANNAEUS SENECA

Fabric. Gatsby's shirts made Daisy cry. The fine linen, silk, and flannel overwhelmed her as she buried her face in them and sobbed. No matter what the fabric, though, men get very attached to their shirts. Some refuse to throw out a well-worn, favorite shirt, because it brings them good luck; others only wear them when they are old, soft, and broken in. But regardless of the fabric, it is a rare man who will actually give you the shirt off his back—unless, of course, it's all she asks for in the morning.

Cotton. Fine dress shirts are made of 100 percent cotton. The highest-quality cottons, Sea Island and Egyptian, are made from the longest, thinnest fibers, or staples, and are slightly sheer. Pima cotton is also made from a long-staple cotton but is not as expensive. The most common type of dress shirt is broadcloth, which refers to the tight weave, not the fabric. Oxford cloth is a rougher weave and therefore less formal. Another indication of fabric quality is the thread count per square inch: the higher the count, the better the fabric.

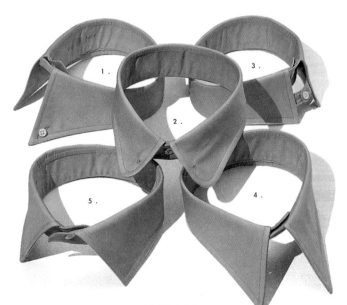

COLLARS

1. Businesslike, but casual: the button-down collar was invented in 1900 by John Brooks (as in Brothers); **2.** Very dressy: when starched and worn with a pin, rounded collars were made famous by Eton schoolboys; **3.** Fastidious: the tab-collar was introduced by the Duke of Windsor; **4.** Universal: straight-point collars are the most versatile style; **5.** Conservative: English spread collars were another Duke of Windsor innovation, designed to accommodate his wide knot.

Collars and Cuffs. These set the tone for an outfit and are often the true sign of a well-dressed man (although frayed collars and cuffs are an affected way to say that you're old money). While there are an infinite number of collar styles—especially if your shirts are custom-made—there are essentially five basic styles. Keep in mind that the collar should complement both the suit and the shape of your face. Men with long, narrow faces, for instance, should avoid long-pointed collars, and round-faced men should beware of spread collars. As for cuffs, no matter what style you select, wear them. Short-sleeve shirts are for guys who star in high-school physics movies.

There are basically three types of cuffs to choose from:

FRENCH CUFFS

are the most dressy—in fact, they may be too formal for certain occasions—and require cuff links.

BARREL CUFFS

are the most common style today, mainly because it is cheaper to make them.

CONVERTIBLE CUFFS

are for the man who hates making up his mind, because they can either button or take cuff links.

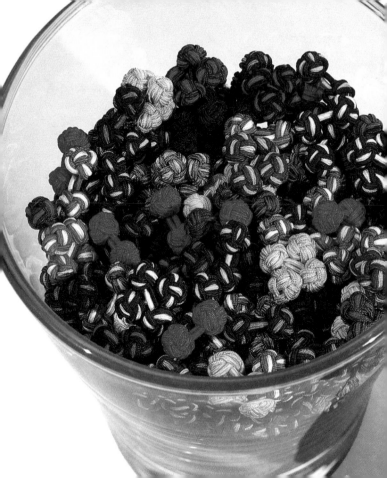

Accessories. Let's face it, women's clothing has better accessories. But a truly well-dressed man pays attention to what few fine points there are. Wearing French cuffs allows a man to agonize over which cuff links to wear; however, silk knots, solid or two-color, are always a safe and elegant choice. Collar bars and collar pins give a man that natty look, but men with short necks should avoid wearing them—you'll look as though you're being squeezed like a tube of toothpaste. And tie bars and tie tacks are also accessories that can add a little finesse to an outfit. But as with all men's jewelry, simple and understated is the way to go—unless you're a two-sport professional athlete.

COLLAR PIN
Fred Astaire wore one with a button-down shirt, but most men wear them with long-point or rounded collars. If the shirt doesn't come with holes, don't worry. The hole you make will disappear when you wash it.

COLLAR STAYS
Playwright Moss Hart had gold-monogrammed collar stays, but many men prefer simpler choices—after all, you're the only one who knows you're wearing them.

TIE CLIP
A tie bar is a stylish way to keep the tie from flying all over the place. It's especially useful for architects, or anyone else who leans over a lot, or works in a wind tunnel.

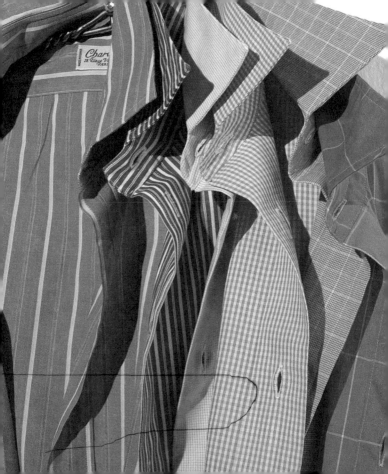

Patterns. Solid shirts have always been the most formal—going back to the days when it was thought that a design was merely camouflaging dirt, the ultimate enemy—but patterned shirts are essentially no less dressy. (In fact, when coupled with a white collar and cuffs, a patterned shirt can seem extremely distinguished, if not a bit priggish.) These days it would be nearly inconceivable to have a wardrobe that didn't include at least a few stripes or checks. What few guidelines there are regarding shirt patterns concern the background color and the size of the pattern: a shirt with a white background is considered more conservative (white being the most formal shirt of all) than a shirt with a colored background. And the smaller the pattern, the dressier the shirt. In other words, a pencil-thin striped shirt is more formal than, say, a candy-striped shirt. Large or frivolously patterned shirts—big gingham checks or multicolored stripes—are associated more with sports shirts than business-wear; although the horizontal-striped shirt is still a must for arbitrageurs.

RUGGED

A denim shirt can inspire many different moods. Put on a bola tie and you're a
cowboy (at least the drugstore variety). Leave the collar open with no tie and it's
a work shirt. Add a funky tie and you're going in style.

*Shirts with white
collars and cuffs connote
a man with a spotless
reputation, which is
perhaps why bankers
prefer them.*

RELAXED
*A shirt with a rougher
weave such as chambray
has a certain charm to
it, a lived-in look. Not
quite dressy, but well-
dressed.*

23

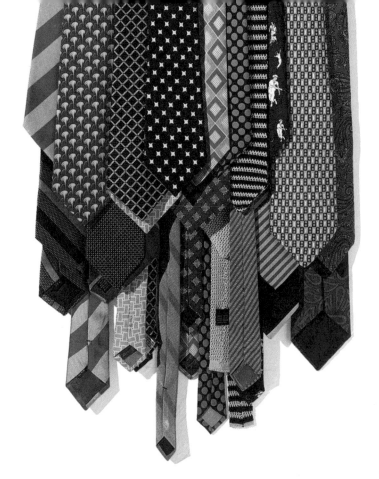

T H E T I E

They are not particularly comfortable. They always go out
of style (or back in as soon as we have thrown them out).
And they are not even practical. Yet the tie remains an essen-
tial part of a man's wardrobe because it unites all the ele-
ments of a man's outfit, gives him instant respectability
and, above all, it is the ultimate symbol of individuality.

> "A well-tied tie is the first serious
> step in life."
>
> OSCAR WILDE

LINING

It allows the tie to knot easily and prevents it from wrinkling. Should be made of 100 percent wool. The greater the number of gold bars on the lining, the heavier the lining.

BAR TACK

This supplements the slip stitch and keeps the two ends of the tie from separating.

THE TIE THAT BUILT AN EMPIRE

Ralph Lauren owes his clothing empire to a tie. In 1967, the shape that Lauren launched under his newly formed Polo label shocked the fashion world. His three-inch-wide tie was seen as heretical compared to the standard narrow, two-inch versions, but it obviously had a wider appeal.

FABRIC

A silk tie should feel smooth; brittleness is usually a sign of inferior material. Three pieces of fabric—cheaper ties use two—allow it to lie better.

HAND ROLLING

A tie that is rolled and hemmed by hand has a better shape to it.

SLIP STITCH

When the slip stitch is pulled, the tie should gather together, which helps maintain its shape.

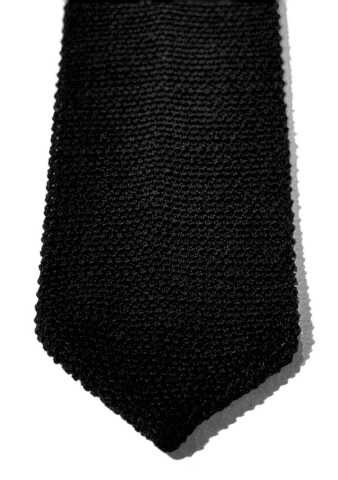

The Simple Tie. Man cannot live by one tie alone—we simply do not eat soup that well—but we can try. In selecting a universal tie, there can be no better inspiration than Ian Fleming's James Bond, who fancied a black silk knit tie with his white silk shirts and blue serge suits. Black, because it goes with just about everything, is appropriate for weddings as well as for funerals (especially funerals), and because stains—remember the soup?—don't show as much. It is also fairly simple to determine whether it works with a particular shirt pattern. The only down side to a black tie is that it may be a bit dark for summer. Silk is the ideal fabric because, well, it's silk and it probably reminded Bond of his sheets. And knit because that nubby texture gives the appearance of a pattern and because it's easy to care for. The only thing to know about a knit tie is that it should be rolled up like a pair of socks (instead of hung on a rack) to prevent stretching. On the other hand, if men did wear only one tie, what would happen to Father's Day?

REPEAT PATTERN

*Whether the design is an amoebic
paisley, small ducks, or a fashion
Rorschach test, this is the most
prolific style of tie.*

four

B A S I C T I E S

A man ought to have about twenty-five to thirty ties in his wardrobe, but he usually wears only a dozen or so (sometimes fewer). So a little economizing wouldn't hurt. The simplest pattern for a tie, obviously, is no pattern at all. A solid tie—although a bit dull when worn with a solid shirt and solid jacket—is the most versatile neckwear because it is appropriate with everything. Of course, no man would actually have an entire wardrobe of solid ties, but in theory he could survive with four basic styles. In theory.

DOT

The smaller the dot, the more formal the tie. Large-polka-dotted ties are more spirited, but are sometimes clownlike.

WOVEN

A woven tie, such as a silk grenadine, is usually produced in a solid color. The texture of the weave serves as the pattern.

STRIPED

*The rep or regimental tie
evolved from displaying the
colors of British clubs or army
regiments. In England the
stripes run from high left to
low right, but in America it's
the other way around.*

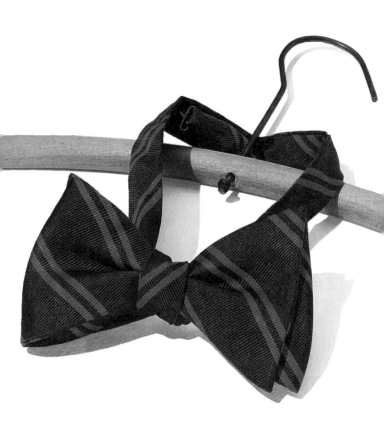

Bow Tie. Except when worn with a dinner jacket, a bow tie generally receives no respect. Clip-ons bring back memories of being four years old and wearing scratchy blazers, while those that are pre-tied and fasten behind the neck are acceptable only for formal wear. Probably the real reason men don't like real bow ties is that not everyone knows how to tie one. Tying a bow tie is actually as simple as tying your shoes.

fig **1.**

fig **2.**

fig **3.**

fig **4.**

fig **5.**

fig **6.**

STEP BY STEP

1. Begin with one end approximately one and one-half inches below the other and bring the long end through the center. **2–3.** Form a loop with the short end, centering it where the knot will be, and bring the long end over it. **4–5.** Form a loop with the long end and push it through the knot behind the front loop. **6.** Adjust the ends slowly. This is where the battle of the bow tie is won or lost.

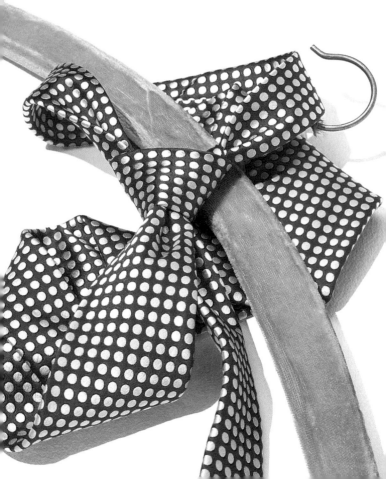

Half Windsor. Whether it was with Wallis Simpson or a handsome piece of silk, the Duke of Windsor knew how to tie the knot. The sartorially splendid Duke liked his necktie knots thick, to complement his wide, spread collars. Today, most men prefer the more modest half-Windsor, which is not as bulky but no less regal.

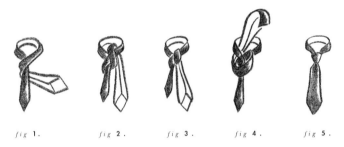

fig **1**. *fig* **2**. *fig* **3**. *fig* **4**. *fig* **5**.

STEP BY STEP

1. Begin with the tie's wide end approximately one foot below the narrow end, and cross it over the narrow end, bringing it back underneath. **2–3.** Take the wide end up through the loop and pass it around the front from left to right. **4.** Then bring it through the loop again and pass it through the knot in front. **5.** Tighten the knot slowly as you draw it up to the collar.

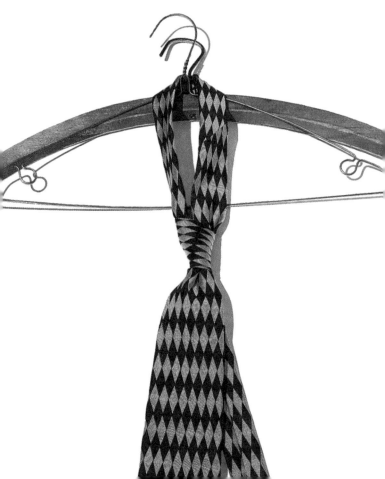

Four-in-hand. This knot was named after the eighteenth-century coach and four drivers who were the first to tie their neck cloths in this manner. The four-in-hand is now the most common method for tying a necktie, largely because it produces a simple, straight knot, and it works well with all fabrics—especially knits and bulky wools.

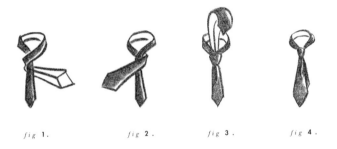

fig **1**. *fig* **2**. *fig* **3**. *fig* **4**.

STEP BY STEP

1. Begin with the tie's wide end approximately one foot below the narrow end, and cross it over the narrow end, bringing it back underneath. 2. Cross the wide end over again and bring it up through the loop. 3. Holding the front of the knot loosely with the index finger, take the wide end through the loop in front. 4. Tighten the knot slowly, holding the narrow end and sliding the knot to the collar.

one

H U N D R E D T I E S

Sometimes a tie is not a tie. Fred Astaire liked to wear his as a belt.

Lou Costello played his like a flute when he was scared. Prep-school

boys hang a knotted tie on the doorknob as a not-too-subtle reminder

that they are entertaining someone inside. Kinkier types (with four-

poster beds) might use a few for a friendly game of Torquemada and the

Naughty Heretic. And at various periods in the twentieth century—most

notably with Diane Keaton in *Annie Hall*—women have liked wearing them.

GOOD USES

Tourniquet NAPKIN *Headband* WHIP *Guitar strap* LEASH *Pocket square*
FLYSWATTER *Loincloth* POM POMS *Slingshot* CORSET *Drapes* BLINDFOLD
Trail blazer ARM SLING *Belt* LANYARD *Luggage strap* GIFT WRAP *Bookmark*
TABLE RUNNER *Macramé pot holder* NECKLACE *Kite tail* SANDAL THONG
Watchband PILLOW ART *Quilt*

QUESTIONABLE USES

FAN BELT *Dish towel* PARACHUTE *Bike lock* COFFEE FILTER *Hammock*
LOOFAH *Dipstick* GARROTE *Handkerchief* TIGHTROPE *Status symbol*
REINS *Ink blotter* WIND SOCK *Bra* SARONG *Fishing line* HANDCUFFS
Jockstrap BUNGEE CORD *Shoelaces* RIPCORD *Towrope*
DENTAL FLOSS *Ink Blotter* NOOSE

"You never get a second chance to make a first impression."

WILL ROGERS

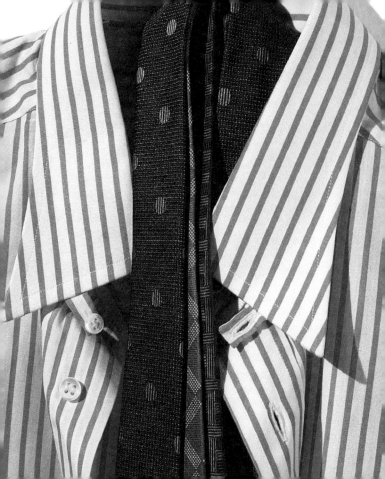

M I X I N G

It happens every morning across the world. A man holds up a shirt and tie and asks, pitifully, "Does this go?" Chances are, if you have to ask, it doesn't. The well-dressed man almost always knows what looks good together. And on those rare occasions when he doesn't, he can usually pull it off anyway.

"Carelessness in dressing is moral suicide."

HONORÉ DE BALZAC

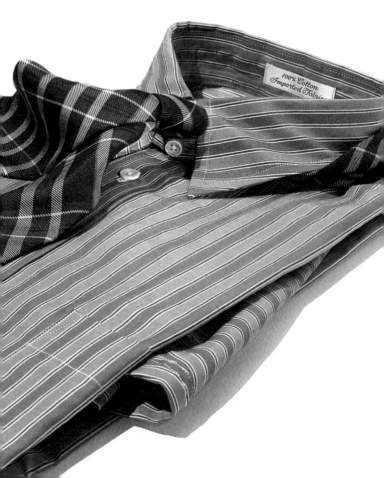

100% Cotton
Imported Fabric

Mixing. How a man puts it all together says a lot about his personality. Wild patterns, wild man. Subtle patterns, subtle man. Simple patterns—well, you get the idea. The old rule for shirts and ties used to call for some combination of two plain (i.e., the shirt and jacket) and one fancy (the tie). Then the rules began to ease up a bit and men could get away with wearing two patterns and one plain, something to neutralize the different designs. These days, for better and for worse, there are no rules. Wearing two patterns is still safe, but who wants to be safe all the time? The truly adventurous man will opt for wearing three: for example, a checked shirt, a polka-dotted tie, and a pin-striped suit. The only caveat for mixing is that the patterns should never be too similar—in other words, choose a bold-striped tie with a thin-striped shirt—since contrast is ultimately what you're after. But bring along plenty of Dramamine for friends, just in case.

FIVE

DAYS

MONDAY, TUESDAY, WEDNESDAY, THURSDAY, FRIDAY

POWER OF THE TIE

As any man who has ever anguished in front of a mirror knows, a necktie can change an entire outfit. A dark tie is considered more appropriate for business, its somber color reflecting an honest work ethic. And when paired with a blue or khaki shirt, a dark tie can evoke the authority of a military uniform. A colorful shirt or tie is usually favored by younger men, or by those in warmer climates. In other words, bright colors that are daring on the East Coast may be considered conservative on the West.

SHIRT TALES

Most of these shirts pick up the base colors of the tie, which is always an important consideration. They also explore the range of formality—from extremely dressy (the white-collared shirt and the blue-and-white antique stripe) to the more casual (the wide blue stripe).

TRAVEL

Ideally, a man could go on a business trip with several shirts and just one tie—if he chooses correctly. Consider a tie that's not too conspicuous, though, or hope that your associates have short memories.

MIX

The repeating pattern of the tie works harmoniously because neither the colors nor the design fight for attention with the shirt.

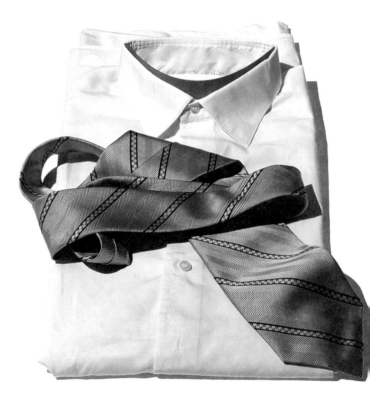

white

THE QUICK CHANGE

*Nothing looks more distinguished on a man than a white shirt.
It connotes instant formality and is never inappropriate. So it's worth keeping a
fresh one—boxed from the cleaner's—in a desk drawer at work for those formal
evenings out when you want to look crisp.*

A NICE SPREAD

*The spread-collar shirt is best suited for a man with a long, narrow
face, as the collar points flatten out the shape of the face. Men with broad or
square faces should avoid them.*

TYING ONE ON

*A formal shirt requires a formal tie. A woven silk tie with a modified
repeating pattern fits the bill.*

*Playing with a particular colour
range may seem a little boring at
first, but it makes getting dressed
a lot easier. Blue is especially
safe because it goes with
anything and is just a notch
below white in formality.*

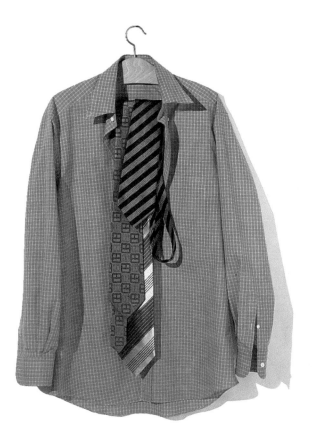

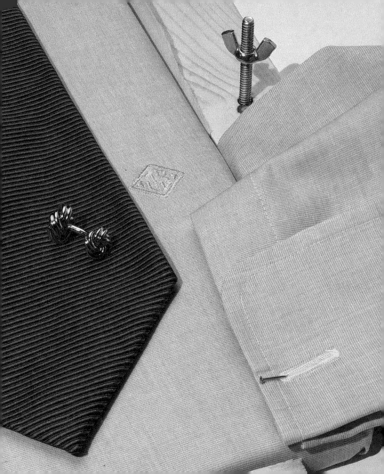

Custom. A custom-made shirt is unquestionably an extravagance, but it's a great way to assert your sartorial individuality. Typically, from the first fitting (where a tailor will take more measurements than you knew you had) to the final product, it takes several weeks to produce a shirt (or shirts, since most custom-made shirt shops require an initial order of three to six shirts). And you should expect to pay about twice as much. The fit will be perfect—tailored to your personal quirks (if you wear a big watch, for instance, have that sleeve made larger)—and the fabric will be superior to that of ready-made shirts.

Having your initials on a shirt is an easy way to customize a shirt. The lettering should be as simple as possible, no more than a half-inch high, and should be embroidered on the pocket, or, because many custom-made shirts do not have pockets—like the one at left, stretched over its monogramming press—about six inches above the waist on the left side. Monograms should never be placed on the sleeve or the collar. The initials needn't be your own, either—your father's, for instance, or maybe your grandfather's.

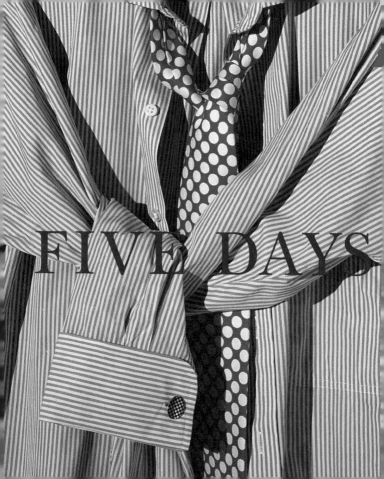

FIVE DAYS

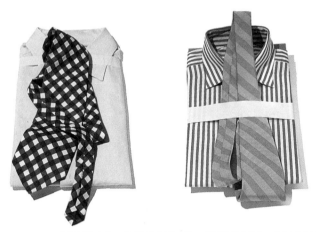

MONDAY, TUESDAY, WEDNESDAY, THURSDAY, FRIDAY

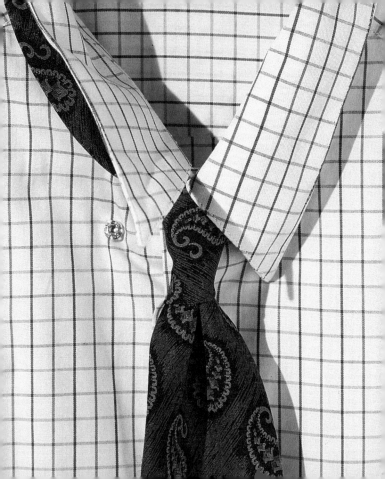

IT'S A SNAP
When Giorgio Armani wanted to create a modern version of the button-down collar, he added snaps to the body of the shirt. It has a neater roll than the traditional button-down, but the snap is usually fragile. Wash and iron with care.

TIES WITH A STORY
Every man should have a tie that defines his individuality— something that says simply and not too obtrusively:
Me.

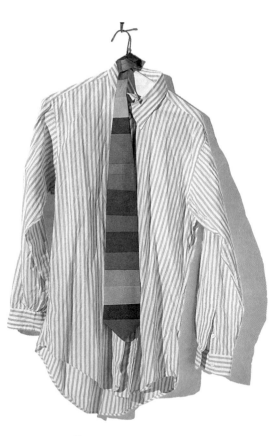

Spring fever can
affect the rules of dress as well. The
patterns get a bit louder and the
colors get a little lighter. And so
does your head.

What to wear with those summer whites? Brightly colored shirts and ties add a little zest to those truly warm weather months. Not to mention that those light sherbet colors keep you cool.

s u m m e r

CHECKS

Sometimes pattern, not color, makes the statement. A checked shirt is an orderly addition to any man's wardrobe. The smaller the check, the dressier the shirt, but, in general, it will dress down a suit.

DOUBLE CHECKS

Unlike a checked shirt, which can be fairly
understated, a checked tie is bold—but the two
patterns can work perfectly together. It's
anything but square.

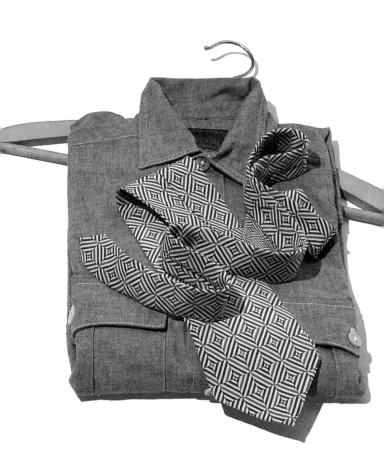

Casual. These are fairly casual days we live in; the rules of dress, especially for business, have eased up considerably. Dress-down days—Fridays, typically—which began on the East Coast (though not on Wall Street or for white-shoe lawyers, heaven forbid), have made their way to the West Coast, where dress codes were always more relaxed to begin with. Even the Oval Office has loosened up a little. There are many elements that can make a man's outfit more casual. The cut of a shirt, for instance, may give it a relaxed feeling; dress shirts are more tapered than sport shirts—although many dress shirts, such as Brooks Brothers's, are incredibly full-cut. And a soft-collared shirt—that is, one without collar stays—is usually pretty sporty. Also, when a shirt has two pockets on the front, it's considered more informal. To complement a casual shirt—if a tie is called for—a funkier tie becomes an option. Once again, it is something that would most likely be improper in the boardroom. Unless, of course, you're the chairman.

CLUBBY

An off-color shirt is better suited to weekends or after work, but the club tie and collar bar give it a formal flair.

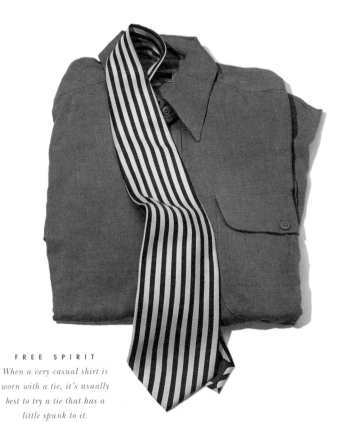

FREE SPIRIT

When a very casual shirt is
worn with a tie, it's usually
best to try a tie that has a
little spunk to it.

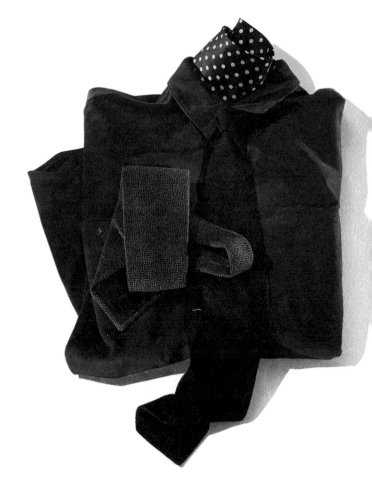

In the Dark. There was a time when wearing a dark dress shirt was associated with Damon Runyon characters. (Shady types, the theory goes, need to blend in with the shadows.) But men are no longer so benighted when it comes to wearing them. In fact, as office dress codes become more relaxed, a dark shirt is becoming an important addition to a man's wardrobe. The key to avoiding that cartoonish gangster look is to stay away from bright ties (especially white) and thick knots. With a dark tie—either a solid, a knit, or a muted pattern—the overall effect, in addition to being remarkably slimming, will be very harmonious. To say nothing of the fact that stains won't show up as easily. A dark dress shirt, however, is probably best worn in the fall and winter when darker colors will keep you warmer and look cozier.

TEXTURE. *Suede is not a common shirt fabric, but, like a soft flannel or a corduroy, it feels great against the skin and is undeniably warm. It's also a tremendous luxury. The result, when paired with a dark, heavy tie, is a kind of professorial look, equally handsome with a pair of gray flannels or a pair of jeans.*

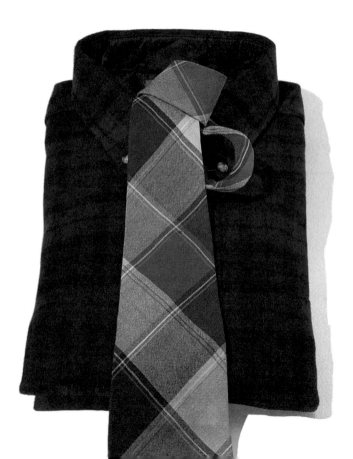

Plaid. Long before there was grunge, there were plaid shirts. Putting one on conjures up images of a nebbishy Woody Allen, manly lumberjacks, or cozy winter evenings in front of a fire. Of course, for many, plaid represents an ancient family tartan. But wearing plaid can also have a more spiritual effect. For some men, for instance, plaid shirts have a paternal association, because it was the only type of shirt they saw their fathers wear on weekends. And while little girls were playing dress-up in Mommy's frilly clothes, little boys were swimming in Dad's oversize flannel shirts, looking for a comfy spot on the couch on which to fall asleep.

PENDLETON

For nearly seventy years, the Pendleton shirt has been a rite of passage in American manhood, somewhere between oiling a baseball glove and buying a first car. Like the heavy wool blankets from which they evolved, Pendleton shirts are made of the finest wools and then meticulously manufactured at their factory in Portland, Oregon. And there are seemingly endless varieties—five different weights, twelve styles, and more than 100 patterns to choose from. After all, there's a lot of manhood out there.

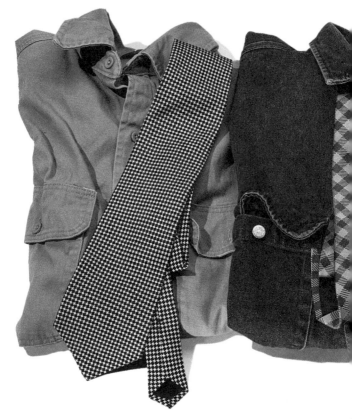

Adding a tie to a favorite weekend shirt can be tricky. How can something so cas
pattern, though somewhat bold. It will be infi

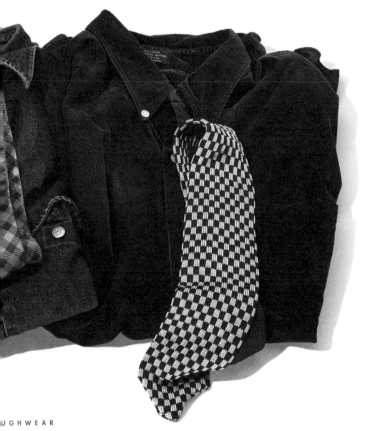

d be matched with a silk tie? The answer is to find something classic—a simple

than what the restaurant will provide.

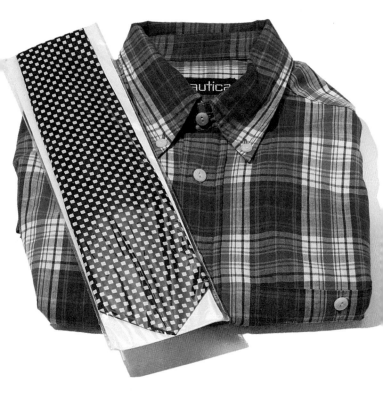

Mail Bonding. Buying a shirt and tie over the phone is a convenient way to shop, even for a man who likes shopping. Obviously, you run the risk of not knowing if something will fit or if the color will be exactly right, but most quality mail-order companies have unconditional return policies—so even if it fits, you don't have to like the way it looks or feels on you. Ties are obviously easier to buy than shirts and they usually come neatly wrapped and wrinkle-free. However, most mail-order merchandise is mass-produced and may not be of the highest quality. But it will probably be cheaper.

SIZE MATTERS

If you don't know your shirt size use a tape measure. To determine the circumference of your neck, measure just below the Adam's apple. To find your sleeve length, measure from the nape of the neck over the outside of the arm to the wrist. If the shirt only lists a neck size, it's safe to assume that a 16 shirt will have about a 35 sleeve, and so on.

NO SWEAT

New York Knicks coach Pat Riley prefers oxford cloth shirts on game days, because they absorb perspiration well.

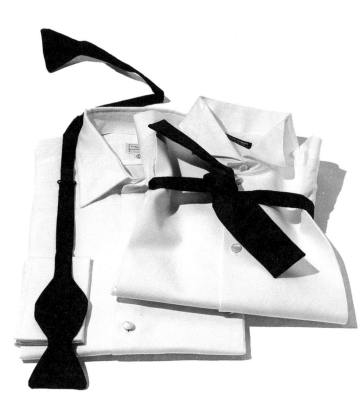

Formal. Even a man who hates wearing a jacket and tie cannot resist the allure of putting on a dinner jacket. He is instantly transformed. Debonair. Accomplished. Destined. There are two types of collars to choose from when selecting a tuxedo shirt. The winged collar, which usually has a piqué front, is the more formal of the two and is particularly flattering on men with long necks. The more comfortable style is the turned-down collar, which usually comes with French cuffs and a pleated front. The pleats should never come below the waistband, or the shirt will billow when you sit down.

BOW TIES

Either a butterfly or a bat-wing bow tie is appropriate. The bow tie should be black, unless it matches the cummerbund, and the material should relate to the lapels: satin for satin, twill for grosgrain.

STUDS AND LINKS

The simpler the jewelry, the better. Most men prefer onyx, silver, or gold, but mother-of-pearl is more appropriate for a white dinner jacket.

first aid.

It's going to happen, no matter how hard we try to prevent it: Red wine or salad dressing on a favorite tie. Tomato sauce on a white shirt. And, of course, lipstick on the collar. Treating a stain is an imprecise science, and sometimes you can do more harm than good. (Sending a tie to a dry cleaner's, for instance, is often disastrous.) There are two basic types of stains: greasy, such as butter or salad oil, which can be treated with cleaning fluid; and non-greasy, such as fruit juice, which will usually come out with water. Sometimes there are combination stains, which require cleaning fluid and then water. For minor spills, home remedies should suffice, but for truly tough problems consult a dry cleaner's. As with anything in life, the sooner you deal with it, the better.

ALCOHOL

WASHABLE FABRICS
The old home remedy of rubbing salt on a wine stain can often set the stain. Use water.

NON-WASHABLE FABRICS
Sponge with water.

BLOOD

WASHABLE FABRICS
Soak in cold water (hot water sets the stain), then launder. If it remains, try a few drops of ammonia and then rewash.

NON-WASHABLE FABRICS
Dab with water and blot dry.

CHEWING GUM

WASHABLE FABRICS
Carefully scrape off the excess without damaging the fabric (harden it first with an ice cube and it will come off more easily). Then launder. If it remains, try a grease solvent.

NON-WASHABLE FABRICS
Same as with washables, but do not launder.

CHOCOLATE

WASHABLE FABRICS
Use soap and water.

NON-WASHABLE FABRICS
Lightly wash with soap and water.

COFFEE AND TEA

WASHABLE FABRICS
If mixed with milk or cream, use cleaning fluid first, then soap and water. If not, use soap and water.

NON-WASHABLE FABRICS
Same as with washables.

FRUITS AND FRUIT JUICES

WASHABLE FABRICS
Sponge the fabric immediately with cold water. Then soak in the laundry. If the stain persists, try a little hydrogen peroxide and chlorine bleach.

NON-WASHABLE FABRICS
Sponge the fabric immediately with cold water. Then try a cleaning fluid.

GRASS STAINS

WASHABLE FABRICS
If fresh (the stain, not the grass), try an enzyme presoak or a heavy-duty detergent. If already set, try a cleaning fluid.

NON-WASHABLE FABRICS
Use dry-cleaning fluid or, if dye-safe, try rubbing alcohol.

GREASE AND TAR

WASHABLE FABRICS
Use cleaning fluid. With tar, chip off the excess and sponge (the inside first) with turpentine.

NON-WASHABLE FABRICS
Same as with washables.

INK

WASHABLE FABRICS
This is often an impossible stain because of the many types of ink. Cold water may do the trick. Otherwise, try a laundry presoak, rubbing alcohol, cleaning fluid, or lemon juice.

NON-WASHABLE FABRICS
Take it to the dry cleaner's.

LIPSTICK

WASHABLE FABRICS
Cleaning fluid, then soap and water. Then a really good excuse.

NON-WASHABLE FABRICS
Cleaning fluid, followed by some water. And an even better excuse.

MILDEW

WASHABLE FABRICS
Treat as soon as possible. Wash thoroughly and dry in the sun. If stain remains, try bleach.

NON-WASHABLE FABRICS
Take it to the dry cleaner's.

PAINT

WASHABLE FABRICS
Read the label carefully. If paint is water-based, use soap and water. If already dry or oil-based, try turpentine.

NON-WASHABLE FABRICS
Take it to the dry cleaner's.

SALAD DRESSING

WASHABLE FABRICS
Treat as a "combination stain." Use cleaning fluid first, then water.

NON-WASHABLE FABRICS
Cleaning fluid, then sponge with water.

SAUCES AND SOUPS

WASHABLE FABRICS
If non-greasy, use water. If a combination stain, use cleaning fluid first, then water.

NON-WASHABLE FABRICS
Cleaning fluid, then sponge with water.

SOFT DRINKS

WASHABLE FABRICS
Sponge immediately with cold water.

NON-WASHABLE FABRICS
Same as with washables.

YELLOWING AND BROWN "AGE" STAINS

WASHABLE FABRICS
Launder with bleach, if safe for the fabric. Or try a rust remover.

NON-WASHABLE FABRICS
Try a dry cleaning fluid if stain is small. Otherwise, take it to the dry cleaner's.

TIE ALTERATIONS

TIE CRAFTERS
252 West 29th Street
New York, NY 10001
212/629-5800
Wherever you live, Tie Crafters can rescue your torn, too-wide, or stained tie.

SEW WHAT?

They will break. They will come off when you are late for dinner. Or when you are on the road. So it's a good idea to know how to sew a button back on. Most quality shirts come with extra buttons, anyway, so don't panic. Besides, once you do it, you'll feel like Betsy Ross.

1. Find a piece of thread approximately six inches to one foot long that matches the thread of the other buttons (usually white), and thread the needle. (When attempting to push the thread through the eye of the needle, some may find it easier to move the needle toward the thread, rather than the opposite.)

2. Pull both ends of the thread even and tie them into a knot.

3. Start by sewing underneath the fabric, pushing the needle up through the button.

4. With each stitch, cross to the button hole diagonally opposite. Two or three times through should do the trick.

5. Then poke the needle through the fabric without going through the buttonhole and wind the thread around the button several times before sewing it through once more. This will reinforce the button.

83

IRON MAN

Some men would sooner die than iron a shirt. It's something you pay other people to do, they say. But some men take tremendous pride in their handiwork—the smooth pocket, the crisp lines of the sleeve—even if they have their shirts professionally laundered. Everyone who does it has his own method for ironing (begin with the back; begin with the sleeves; begin with the collar), but basically you can figure out for yourself what works best. A few helpful hints:

1. If the shirt is dry, use a little spray starch. It can work wonders.

2. Iron the underside of the cuffs and the collar first, then the side that shows. Use the point of the iron for finesse.

3. Pull the shirt fabric slightly as you go along. It makes for smoother ironing.

4. Iron around buttons, not on top of them.

5. Pay special attention to the placket. It may be obscured by the tie, but it will make the shirt look crisper.

TO STARCH OR NOT TO STARCH

For men who get their shirts professionally laundered, there is only one consideration: starch. While it may make the shirt look stiff and smooth, it can also be treacherous for the material. The simplest precaution is to starch only the collars and the cuffs, and not every time you have the shirt laundered. If you insist on having a stiff collar, try some spray starch. As for boxing versus hangers: Shirts that are laundered and put on hangers are usually more expensive and don't come back with creases. But shirts that are boxed make sense for a man who travels. They pack beautifully when boxed.

WHEN IN EUROPE...

Equivalent sizes when shopping abroad:

American/English:

| 14 | 14½ | 15 | 15½ | 16 | 16½ | 17 |

Continental:

| 36 | 37 | 38 | 39 | 41 | 42 | 43 |

where. A Chic Simple store looks

out on the world beyond its shop window. Items are practical

and comfortable and will work with pieces bought elsewhere. The

store can be a cottage industry or a global chain but even with an

international vision it is still rooted in tradition, quality, and value.

United States

CALIFORNIA

FRED SEGAL
8100 Melrose Avenue
Los Angeles, CA 90046
213/651-3342

MAXFIELD
8825 Melrose Avenue
Los Angeles, CA 90069
310/274-8800

WILKES BASHFORD
375 Sutter Street
San Francisco, CA 94108
415/986-4380

GEORGIA

RICH'S
Lenox Square Shopping Mall
3393 Peachtree Road
Atlanta, GA 30326
404/231-2611

ILLINOIS

BIGSBY & KRUTHERS
1750 North Clark Street
Chicago, IL 60614
312/440-1700 for other
Illinois listings

LOUISIANA

RUBENSTEIN BROS.
102 St. Charles Avenue
New Orleans, LA 70130
504/581-6666 for other
Louisiana listings

MASSACHUSETTS

LOUIS, BOSTON
234 Berkeley Street
Boston, MA 02116
617/262-6100
800/225-5135

NEW YORK

ADDISON ON MADISON
698 Madison Avenue
New York, NY 10021
212/308-2660

725 Fifth Avenue
New York, NY 10022
212/832-2000

ASCOT CHANG
7 W. 57th Street
New York, NY 10019
212/759-3333

BERGDORF GOODMAN
MEN
745 Fifth Avenue
New York, NY 10022
212/753-7300

BRIAN BUBB
135 Fifth Avenue, 2nd floor
New York, NY 10010
212/777-1299

DOLLAR BILL'S
99 East 42nd Street
New York, NY 10017
212/867-0212

NORTH CAROLINA

JULIAN'S COLLEGE
SHOP
140 East Franklin Street
Chapel Hill, NC 27514
919/942-4563

PENNSYLVANIA

ALLURE MEN'S
CLOTHING
1509 Walnut Street
Philadelphia, PA 19102
215/561-4242

LAST CALL AT NEIMAN
MARCUS
1887 Franklin Mills Circle
Franklin Mills Mall
Philadelphia, PA 19154
215/637-5900

WAYNE EDWARD'S
1521 Walnut Street
Philadelphia, PA 19102
215/563-6801

WASHINGTON, D.C.

BRITCHES GREAT
OUTDOORS OUTLET
1357 Wisconsin Avenue, N.W.
Washington, DC 20007
202/337-8934

NATIONAL AND
INTERNATIONAL
LISTINGS

AGNÈS B.
116 Prince Street
New York, NY 10012
212/925-4649

6, rue du Jour
75001 Paris
40/03-45-00

ALFRED DUNHILL OF
LONDON LTD.
30 Duke Street
London SW1 Y6DL
71/499-9566
212/888-4000 for listings in
the United States

ARMANI A/X
568 Broadway
New York, NY 10012
212/431-6000
212/570-1122 for Armani
Stores worldwide

BANANA REPUBLIC
130 East 59th Street
New York, NY 10022
212/751-5570
212/446-3995 for listings in
the United States

BARNEYS NEW YORK
111 Seventh Avenue
New York, NY 10011
212/929-9000

BLOOMINGDALE'S
1000 Third Avenue
New York, NY 10022
212/355-5900 for listings in
the United States

BROOKS BROTHERS
346 Madison Avenue
New York, NY 10017
212/682-8800
800/444-1613 for listings in
the United States
800/274-1815 for catalogue

BURBERRYS LTD.
1822 Haymarket, SW1 Y4DQ
71/930-3343

165 Regent Street A8AS
London W1
71/734-4060
800/284-8480 for listings in
the United States

CALVIN KLEIN
199 Boylston Street
Boston, MA 02167
617/527-8975

COUNTESS MARA
445 Park Avenue
New York, NY 10022
212/751-5322

THE CUSTOM SHOP
618 Fifth Avenue
New York, NY 10020
212/245-2499

DAYTON'S
700 On The Mall
Minneapolis, MN 55402
612/375-2200

DILLARD'S PARK
PLAZA
Markham & University
Little Rock, AR 72205
501/661-0053

EMPORIO ARMANI
110 Fifth Avenue
New York, NY 10011
212/727-3240

ERMENEGILDO ZEGNA
743 Fifth Avenue
New York, NY 10022
212/421-4488

via Petro Verri, 3
Milan
2/795521

F.R. TRIPLER & CO.
366 Madison Avenue
New York, NY 10017
212/922-1090

THE GAP/BANANA
REPUBLIC
1 Harrison Street
San Francisco, CA 94105
415/777-0250

GIORGIO ARMANI
815 Madison Avenue
New York, NY 10021
212/988-9191

GIORGIO ARMANI
via Borgonuvo, 21
Milan 2021
2/7600-3234

GUCCI
685 Fifth Avenue
New York, NY 10022
212/826-2600

HERMÈS
24 rue du Faubourg Saint-
Honoré
75002 Paris
40/17-47-17
212/751-3181 for listings in
the United States

J. CREW
203 Front Street
New York, NY 10038
800/782-8244
Catalogue available

THE JOSEPH ABBOUD
STORE
37 Newbury Street
Boston, MA 02116
617/266-4200

THE KNOT SHOP
57 W. Grand Avenue,
7th floor
Chicago, IL 60614
312/644-5668 for listings in
the United States

R.H. MACY'S INC.
(AEROPOSTAL)
Macy's Herald Square
151 W. 34th Street
New York, NY 10001
212/695-4400 for East Coast
listings
415/954-6000 for West Coast
listings

MARK SHALE
919 North Michigan Avenue
Chicago, IL 60611
312/440-0720 for West and
Midwest listings

NAUTICA
40 W. 57th Street
New York, NY 10019
212/541-5757

NEIMAN MARCUS
1618 Main Street
Dallas, TX 75201
214/573-5780

NORDSTROM
1501 Fifth Avenue
Seattle, WA 98101
206/628-2111
800/695-8000 for
Nordstrom catalogue

PARISIAN
2100 River Chase Galleria
Birmingham, AL 35244
205/987-4200

PAUL SMITH LTD
41-44 Floral Street
London WC23 9DJ
71/379-7133
212/627-9770 for worldwide
info

PAUL STUART
Madison Avenue
at 45th Street
New York, NY 10017
212/682-0320 for worldwide
info

PENDLETON WOOLEN
MILLS
489 Fifth Avenue, 25th floor
New York, NY 10022
212/661-0655

POLO/RALPH LAUREN
867 Madison Avenue
New York, NY 10021
212/606-2100

SAKS FIFTH AVENUE
611 Fifth Avenue
New York, NY 10022
212/753-4000 for listings in
the United States

SULKA
430 Park Avenue
New York, NY 10022
212/980-5200

SULKA
2, rue de Castiglione
75001 Paris, France
42/60-38-08

TIE RACK
Capital Interchange Way
Brentford
Middlesex TW8 OEX
81/9951344 for
international listings
416/470-6290 for listings in
the United States and
Canada

TINO COSMA
BOUTIQUE
692 Fifth Avenue
New York, NY 10019
212/246-4005 for info and
Italian listings

URBAN OUTFITTERS
1801 Walnut Street
Philadelphia, PA 19103
215/564-2313 for listings in
the United States

ACCESSORIES

ASPREY
725 Fifth Avenue
New York, NY 10022
212/688-1811

CARTIER
653 Fifth Avenue
New York, NY 10022
212/446-3459

MUSEUM OF MODERN
ART DESIGN STORE
44 West 53rd Street
New York, NY 10019
212/767-1050

TIFFANY & CO.
727 Fifth Avenue
New York, NY 10022
212/755-8000
212/605-4612 for worldwide
info

VINTAGE AND
NOVELTY TIES

AMERICAN RAG CIE
150 South La Brea
Los Angeles, CA 90036
213/935-3154

AMERICAN RAG
COMPONENTS
9, rue de Turbigo
75001 Paris
45/08-96-10

FRANKEL CLOTHING
EXCHANGE
123 Church Street
Toronto, Canada M5C 265
416/366-4221

TRASH & VAUDEVILLE
4 St. Mark's Place
New York, NY 10003
212/777-1727

CATALOGUES AND
MAIL ORDER

EDDIE BAUER
1330 Fifth, at Union
Seattle, WA 98101
206/622-2766

LANDS' END
Lands' End Lane
Dodgeville, WI 53595
800/356-4444

TWEEDS
115 River Road
Edgewater, NJ 07020
800/999-7997

WIRELESS
P.O. Box 64422
St. Paul, MN 55164-0422
800/669-9999 for novelty
ties

INTERNATIONAL
LISTINGS

Australia

MELBOURNE

GEORGES AUSTRALIA
LTD
162 Collins Street
3/283-5555

SYDNEY

DAVID JONES
86-108 Castleray Street
2000
2/266-5544

GOWING BROTHERS
45 Market Street
2000
2/264-6321
Catalogue available

GRACE BROS.
436 George Street
2000
2/218-1111

Canada

MONTREAL

OGILVY
1307 rue Sainte-Catherine
ouest
514/842-7711

L'UOMO
1452 Peel, at Sainte-
Catherine ouest
514/842-7711

TORONTO

THE BRICK SHIRT
HOUSE
112 Cumberland Street
416/964-7021

HOLT RENFREW
50 Bloor Street West
416/922-2333 for stores
throughout Canada,
including Quebec
Point of View catalogue
available

VANCOUVER

EDDIE BAUER
Pacific Centre Mall
V71 E4
604/683-4711

France

PARIS

ALAIN FIGARET
21, rue de la Paix
75002
42/65-04-99

CHARVET
28, Place Vendôme
75001
42/60-30-70

CHRISTIAN DIOR
13, rue François
40/73-54-44

CRAVATTERIE
NAZIONALE
249, rue Saint-Honoré
42/61-50-39 for info and for
stores in Rome, Milan, and
Monte Carlo

GALERIES LAFAYETTE
(GALFA CLUB)
40, boulevard Haussmann
75009
42/82-34-56

HEMISPHERES
1, boulevard Emile-Augler
75016
45/20-13-75

22, avenue de la Grande-
Armée
75017
42/67-61-86

HERMÈS
24, rue de Faubourg
Saint-Honoré 75016
40/17-47-17

HILDITCH & KEY
252, rue de Rivoli
75001
42/60-36-09

LANVIN
15, rue de Faubourg Saint-
Honoré
75008
42/65-14-40

PRINTEMPS
(BRUMMEL)
112, rue de Provence
75009
42/82-50-00

Germany

BERLIN

SELBACH
Kürfürstendamm 195
30/883-2526

DÜSSELDORF

HARIR BRAUN
Kronprinzenstrasse 129
Backerei
211/304510

HEINEMAN MODEHAUS
Königsallee 18
211/130760

FRANKFURT

HENRY
Goethestrasse 13
6000
69/28884

MOELLER & SCHAAR
Goethestrasse 26–28
6000
69/282855

MUNICH

MEY & EDLICH
Schlosstrasse 27–28
30/791-5030 in Berlin (also
in Hamburg and Frankfurt)

STUTTGART

BREUNINGER
Friedhofstrasse 71
711/257-7507

HOLY'S
Residenzstrasse 15
8000 Munich 2
89/226-422 for info and
listings in Germany

Great Britain

LEICESTER

NEXT PLC
Bedford Road,
Enderby LE9 5AT
533/849424

LONDON

BHS
252–258 Oxford Street
W1N 9DC
71/629-2011

BOWRING, ARUNDEL &
COMPANY
31 Savile Row
W1X 1AG
71/629-8745

BROWNS
23 South Molton Street
W1Y 1DA
71/491-7833

CERRUTI 1881
76 New Bond Street
W1Y 9DB
71/493-2278

CORDINGS
19 Piccadilly
W1
71/734-0830

GUCCI LTD
32-33 Old Bond Street
W1
71/235-6707

HACKETTS
GENTLEMAN'S
CLOTHIERS
136–138 Sloane Street
SW1
71/730-3331

HARVEY NICHOLS &
CO. LTD.
109–125 Knightsbridge
SW1X 7RJ
71/235-5000

HENRY COTTONS
175 Sloane Street
SW1
71/235-5440
179 New Bond Street
71/434-0605

LIBERTY
210–220 Regent Street
W1
71/734-1234

MARKS & SPENCER PLC.
458 Oxford Street
W1
71/935-4422

MOSS BROTHERS
CECIL GEE
SAVOY TAILORS GUILD
THE SUIT COMPANY
8 St. John's Hill
Clapham Junction
SW11 1SA
71/924-1717

MUJI
26 Great Marlborough
Street
W1V H1B
71/494-1197

NEW AND LINGWOOD
53 Jermyn Street
SW1
71/493-9621

PAUL SMITH LTD
41–44 Floral Street
WC2E 9DJ
71/379-7133

THOMAS PINK LTD
35 Dover Street
W1
71/498-2202

TIE RACK
Capital Interchange Way
Brentford, Middlesex
81/995-1344

TURNBULL & ASSER
71–72 Jermyn Street
SW1
71/930-0502

Italy

MILAN

ETRO
Via Montenapoleone, 5
2/550201

ROME

ALBERTELLI
Via dei Prefetti, 11
6/6873401

IL DISCOUNT
DELL'ALTA MODA
Via Gesù e Maria, 16/a

Japan

TOKYO

BERKELEY
4 30-6 Gingumae
Shibuya-ku
3/3401-7185

COMME DES GARÇONS
5-11-1 Minamioyama
Minato-ku
3/207-2480

EIKOKUYA
2 Chome Ginza-dori
Chuo-ku
3/3563-2941

ISETAN
3-14-1 Shinjuku-ku
3/3352-1111

ISSEY MIYAKE MEN
Vingt-Sept Building
3-18-11 Minami-Aoyama
Minato-ku
3/3423-1407

MATSUDA
3-22-5 Yuehara
Shibuya-ku
3/34-65-1484

MITSUKOSHI
1-4-1 Nihonbashi-
Muromachi
Chuo-ku
3/3241-3311

PARCO
15-l Udagawa-cho
Shibuya-ku
3/3464-5111

TAKASHIMAYA
2-4-1 Nihonbashi
Chuo-ku
3/3211-4111

RESOURCES

COVER FRONT

 COTTON SHIRT - Hackett
 SILK TIE - Giorgio Armani

BACK

 (Clockwise from top left)
 COTTON SHIRT - J. Crew; **SILK TIE** -
 Prochownick; **COTTON SHIRT**- Garrick
 Anderson; **CUFF LINKS** - James
 Robinson; **SILK KNIT TIE** - Hackett;
 COTTON SHIRT - Charvet; **SILK TIE** -
 Hackett; **ANTIQUE GOLD TIE BAR** -
 Sentimento; **COTTON SHIRT** - Ike
 Behar; **SILK TIE** - Hackett

THE SHIRT

10 **COTTON SHIRTS** (from top) - Polo;
 Vestimenta; Alan Flusser; Brooks Brothers
12 **COTTON SHIRT** - Brooks Brothers
14 **SHIRTS** (from top) Charvet; J. Crew;
 Alan Flusser; Hackett; Brooks Brothers
16–17 **COLLARS AND CUFFS** - Bergdorf
 Goodman Men

18 **SILK KNOT CUFF LINKS** - Paul Stuart
20 **COTTON SHIRTS** (from left)-
 Charvet; Nautica; Ermenegildo Zegna;
 Ermenegildo Zegna; Ermenegildo
 Zegna; Giorgio Armani
22 **DENIM SHIRT** - The Gap
23 **SHIRTS** (from left) - Ferrell Reed;
 Garrick Anderson

THE TIE

24 **SILK TIES** (from left) - Garrick
 Anderson; Gucci; Turnbull & Asser;
 Hackett; Ermenegildo Zegna; Richel;
 Hackett; Paul Stuart; Mount Royal;
 Rooster; Garrick Anderson; Hackett;
 Ermenegildo Zegna; XMI; Hackett;
 Brian Bubb; Charvet
26–27 **SILK TIE** - Polo/Ralph Lauren
28 **KNIT TIE** - Donna Karan Men
30 **SILK TIE** - Gucci
32–33 **SILK TIES** (from left) Tino Cosma;
 Hackett; Sulka
34 **SILK BOW TIE** - Brooks Brothers
36 **SILK TIE** - Bill Robinson
38 **SILK TIE** - Hackett

MIXING

42 **COTTON SHIRT** - Luigi Borrelli;
 SILK TIES (from left) - Ike Behar;
 Countess Mara; Countess Mara
44 **COTTON SHIRT** - Burberry's;
 WOOL TIE - Garrick Anderson

46 **COTTON SHIRT** - Turnbull & Asser;
SILK TIE - Garrick Anderson
47 (Clockwise from top left) **COTTON
SHIRT** - J. Crew; **SILK TIE** -
Prochownick; **COTTON SHIRT** -
Garrick Anderson; **CUFF LINKS** - James
Robinson; **SILK KNIT TIE** - Hackett;
COTTON SHIRT - Charvet; **SILK TIE** -
Hackett; **ANTIQUE GOLD TIE BAR** -
Sentimento; **COTTON SHIRT** - Ike
Behar; **SILK TIE** - Hackett
48–49 **COTTON SHIRTS** (outer) - Arrow;
(inner, hanging) - Kenneth Gordon;
(folded) - Sero; **SILK TIES** (from left) -
Romeo Gigli; Paul Smith
50–51 **COTTON SHIRTS** (from top) - Gordian
Knot; Sulka; Garrick Anderson; Hackett;
Ferrell Reed; **SILK TIE** - Sulka
52 **COTTON SHIRT** - The Shirt Store;
SILK TIE - Ferrell Reed
54 **COTTON SHIRT** - Gucci; **SILK TIE** -
Garrick Anderson
55 **COTTON SHIRT** - Ermenegildo Zegna;
SILK TIES (from top to bottom) -
Burberry's of London; Gucci; Garrick
Anderson
56 **COTTON SHIRT** - The Custom Shop;
GOLD CUFF LINKS - Tiffany & Co.;
SILK TIE - Garrick Anderson
58 **COTTON SHIRT** - Alexander Julian;
SILVER & ENAMEL CUFF LINKS -
Asprey; **SILK TIE** - Ermenegildo Zegna

59 (Clockwise from top left) **COTTON
SHIRT** - Hackett; **SILK TIE** - Echo;
COTTON SHIRT - Hackett; **SILK TIE** -
Ferrell Reed; **COTTON SHIRT** -
Workwear by Country Road Australia;
SILK TIE - Hermès; **COTTON SHIRT** -
Alan Flusser; **SILK TIE** - Alfred Dunhill
60 **SHIRT & TIE** - Giorgio Armani
61 **COTTON SHIRT** - Paul Stuart; **SILK TIE** -
Gene Meyer
62 **COTTON SHIRT** - Yves Saint Laurent;
SILK TIES (from left) - Huberteam;
Garrick Anderson; Ferrell Reed
63 **SHIRT & TIES** - Faconnable
64–65 **SILK TIE** - Ferrell Reed; **COTTON
SHIRTS** (from top) - Ike Behar; J. Crew;
Charvet; Ferrell Reed
66 **CHAMBRAY SHIRT** - Armani A/X;
SILK TIE - Burberry's of London
68 **COTTON SHIRT** - Charvet; **SILVER
COLLAR BAR** - Neiman Marcus; **SILK
TIE** - Paul Stuart
69 **WOOL SHIRT** - Joseph Abboud; **SILK
TIE** - Garrick Anderson
70 **NUBUCK SHIRT** - Robert Comstock;
TIES (clockwise from top) - Ferrell
Reed; Polo/Ralph Lauren; Joseph
Abboud
72 **WOOL SHIRT** - Pendleton; **VINTAGE
TIE** - Sixth Avenue Antique Market,
New York, New York

74–75 (From left)- **TAN DENIM SHIRT** - Carhartt; **COTTON TIE** - J. Crew; **BLUE DENIM SHIRT** - Thornton Bay, Macy's; **SILK TIE** - Garrick Anderson; **CORDUROY SHIRT** - J. Crew; **SILK TIE** - Ermenegildo Zegna

76 **COTTON SHIRT** - Nautica; **COTTON TIE** - J. Crew

78 **COTTON PIQUÉ SHIRTS** (from left) - Hackett; Giorgio Armani; **SILK BOW TIES** (from left) - F. Tripler & Co.; Brooks Brothers

79 **COTTON PIQUÉ SHIRT** - Giorgio Armani; **SILK BOW TIE** - Giorgio Armani

QUOTES

2 **OSCAR WILDE**, *Phrases and Philosophies for the Use of the Young*

11 **COLE PORTER**, *The Complete Lyrics of Cole Porter* (New York: Alfred A. Knopf, 1983)

13 **LUCIUS ANNAEUS SENECA**

25 **OSCAR WILDE**, *The Importance of Being Earnest*

41 **WILL ROGERS**, as quoted in *Class, Class, Class, What It Is and How to Acquire It*, by Mortimer Levitt (New York: Atheneum, 1984)

43 **HONORÉ DE BALZAC**, *Treatise on the Elegant Life*

96 **IVAN TURGENEV**, *Virgin Soil*

ACKNOWLEDGMENTS

Rosie Boycott, Beth Chang, Tony Chirico, M. Scott Cookson, Lauri Del Commune, Dina Dell'Arciprete, Chris Di Maggio, Michael Drazen, Jane Friedman, Janice Goldklang, Jo-Anne Harrison, Patrick Higgins, Katherine Hourigan, Andy Hughes, Grace Iida, Carol Janeway, Toru Kagami, Nicholas Latimer, Karen Leh, Mortimer Levitt, William Loverd, Anne McCormick, Sonny Mehta, Mitchell Rosenbaum, Hellyn Sher, Anne-Lise Spitzer, Meg Stebbins, Stonehenge, NY, Robin Swados, Kim Turner, Shelley Wanger, Wayne Wolf, Alice Wong, Mitsuo Yamada.

A NOTE ON THE TYPE

The text of this book was set in New Baskerville, the ITC version of the typeface called Baskerville, which itself is a facsimile reproduction of types cast from molds made by John Baskerville (1706–1775) from his designs. Baskerville's original face was one of the forerunners of the type style known to printers as the "modern face"— a "modern" of the period A.D. 1800.

SEPARATION AND FILM PREPARATION BY
APPLIED GRAPHICS TECHNOLOGIES
Carlstadt, New Jersey

PRINTED AND BOUND BY
**IMPRESORA DONNECO INTERNACIONAL,
S.A. De C.V.**
Reynosa, Mexico

"I could not simplify myself."

IVAN TURGENEV,

from the suicide note in Virgin Soil

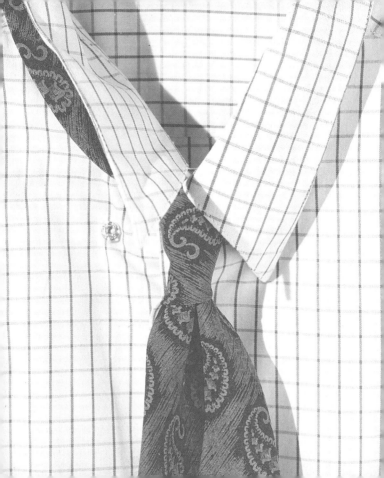